Poetic Imagery

Photographs Copyright ©2016 David Rothbart

Poems Copyright ©2016 Frederick E. Whitehead

All rights reserved. No part of this book may be reproduced or transmitted in any form or by any means, electronic or mechanical, including photocopying and recording, or by any information storage or retrieval system except as may be expressly permitted by the author.

ISBN-13: 978-1533062499

Introduction

Visual "reflectionism" transports the observer past the obvious and projects the images to a surreal depth within the photograph. We tend to look at our world without seeing the unique layers before us. Photographic reflectionism allows us to see what is behind and in front of the subject image creating a story within the two dimensional scene before us. When we observe these images in the real world we are obviously seeing a 3 dimensional scene. Using the technique of reflectionism we are able to project those same 3 dimensional images onto a 2 dimensional canvas thereby changing our perception and creating a new realism. Training the eye to look at objects and concentrating on the fore and background will help to hone the observer's perception to a better understanding of how reflectionism works. As the new dimension of reflectionism perfects within the observer's eye, exciting perceptional changes of images will open up creating an awareness within the photographs that may not have been realized before. By adding poetry to the photographs in this book, our desire is to stimulate the observer's mind to further animate the images before them. This book is not intended to make you a reflectionism expert but it will help the reader to have a visual understanding about how poetry combined with reflectionism based photographs can help to stimulate a visual perception of objects that you may have not imagined before.

David Rothbart's love of fine arts started when he was a child. His mother was an artist specializing in oil and watercolor painting. Through her education and action, he learned to appreciate the history, depth, and creation of art. During the mid-1960's David began to experiment with photography. When he first started he, like most photographers, focused on the equipment used. As he progressed and honed his art David put less emphasis on the equipment and began to focus more on developing his eye and sense of subject selection. Over the years he learned how to use planning and visualization of the shot before he hit the shutter taking into account geometry and lighting along with subject matter. David loves architecture along with the surreal world of reflection and has made them the major emphasis of his work creating a style he calls Reflectionism.

"In any art medium I think it is important to discover the niche that grabs your soul and keeps your drive to create in constant motion".

Frederick E. Whitehead is a Buffalo area poet who has had a blog at fewhitehead.wordpress.com since 2010. He is the author of seven volumes of poetry. His latest, titled Luna, came out in March of 2016. He is also the host of Dog Ears 4th Friday Poetry Series at Dog Ears Bookstore & Café in South Buffalo. In his spare time he publishes limited run chapbooks through his Destitute Press.

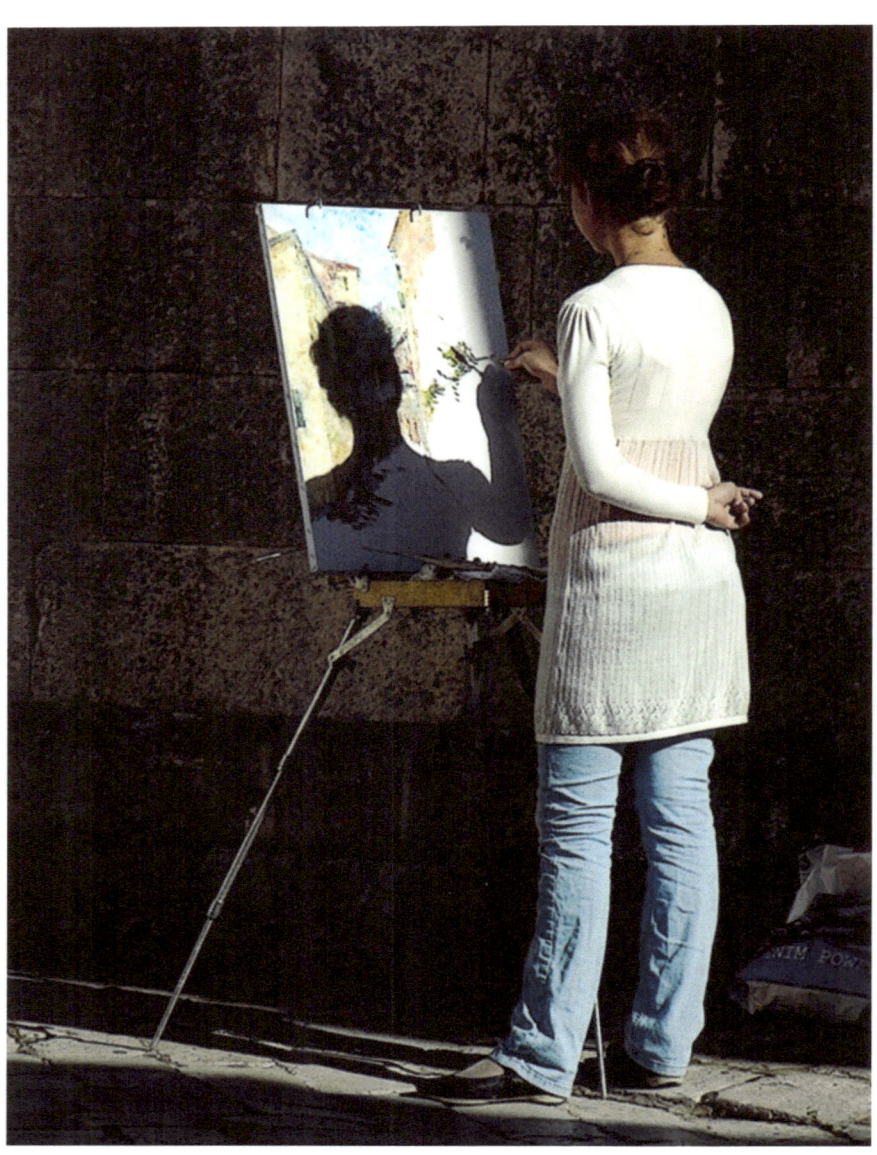

It may be only a shadow

or perhaps a reflection

that can be

considered as

proof

of your creations

recognizing your recognizing

them as sentient

they wait as you apply the final touch

watching for that tale tell

turn of the lip - reading the

wrinkles

webbing

about the eyes

matching in prefect unison

the slow exhalation

that signifies completion

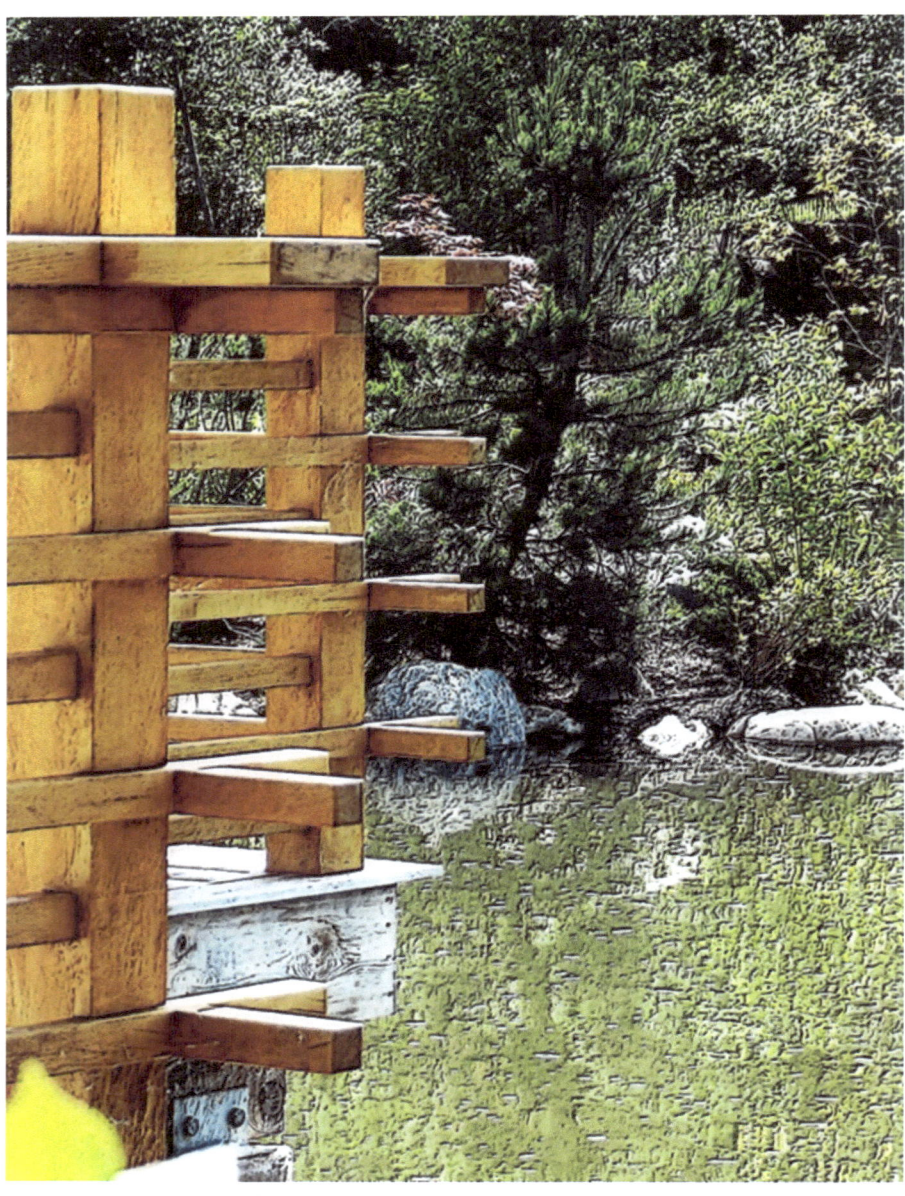

Tranquility is that
 which is woven
with every
 breath taken slowly
when circumstances
 would have
 had it
 otherwise

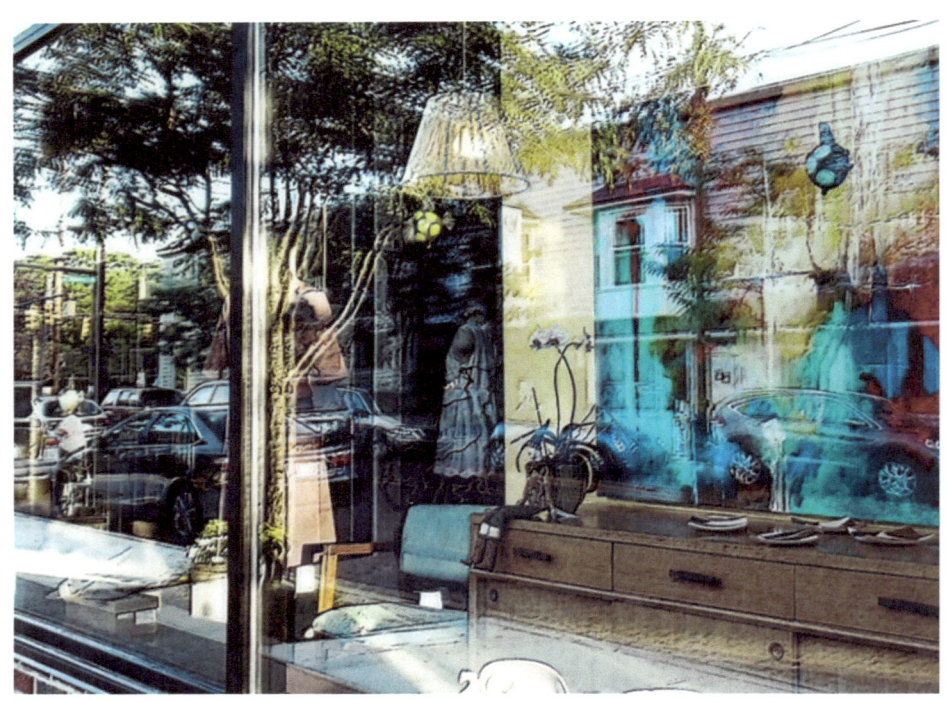

The depth of existence

can not by man

be measured

life but

a millisecond

captured on a layer

of acetate and stacked

each reflecting or

melding with the previous

the picture

always changing

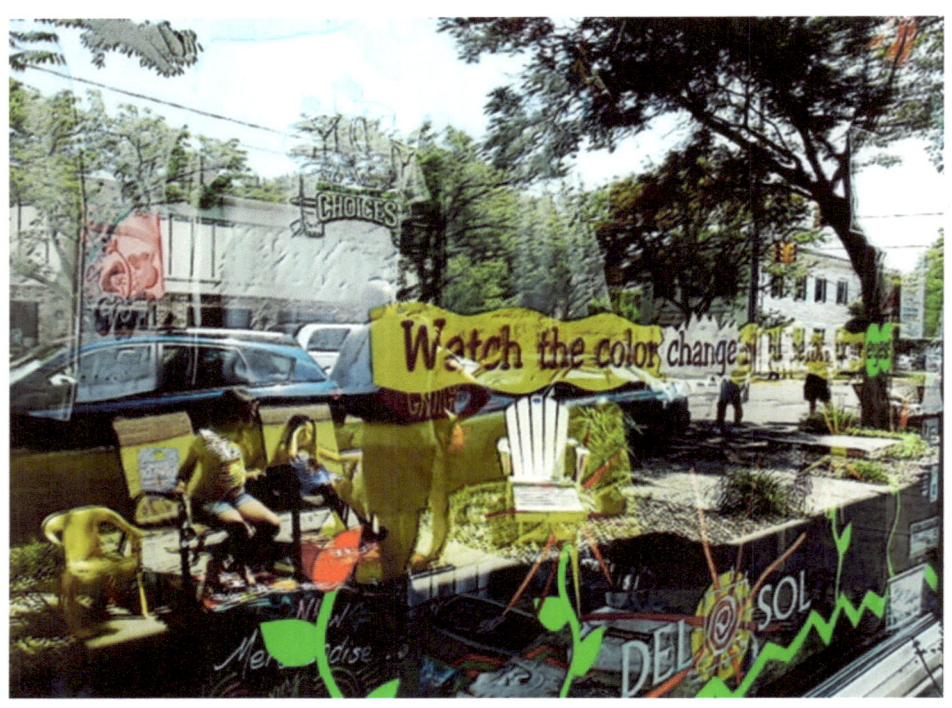

Sometimes

going into the depths

whichever direction

that implies

opens you to the

warmth

of different suns

the looking glass

 accepted Alice

 the doors,

 Huxley the eyes of a love

 (epitomizing depth)

anyone willing

to hold their breath and dive

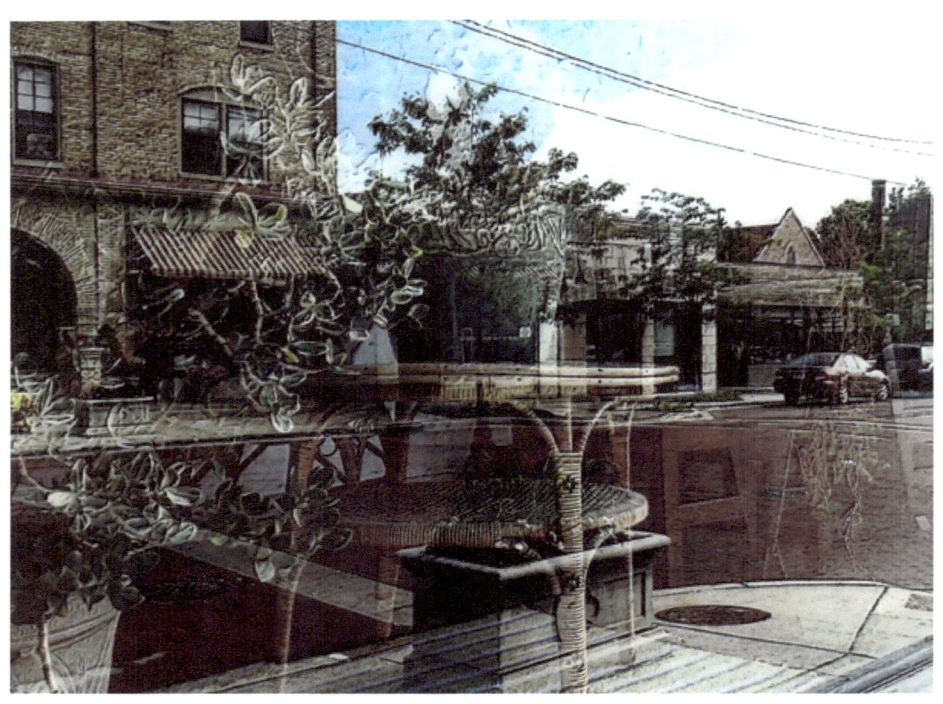

As you set a table for ghosts

above you

a ribbon of gold appears

on the leading edge

of a morning storm

positioning cups

laying silver

bundled in silk

alongside plates

chipped by years of tradition

you are

stirred by

conversations revisited

in your mind

you glance at the clock

as the sky darkens and

sit facing the window

to let coffee warm you

waiting on a break in the clouds

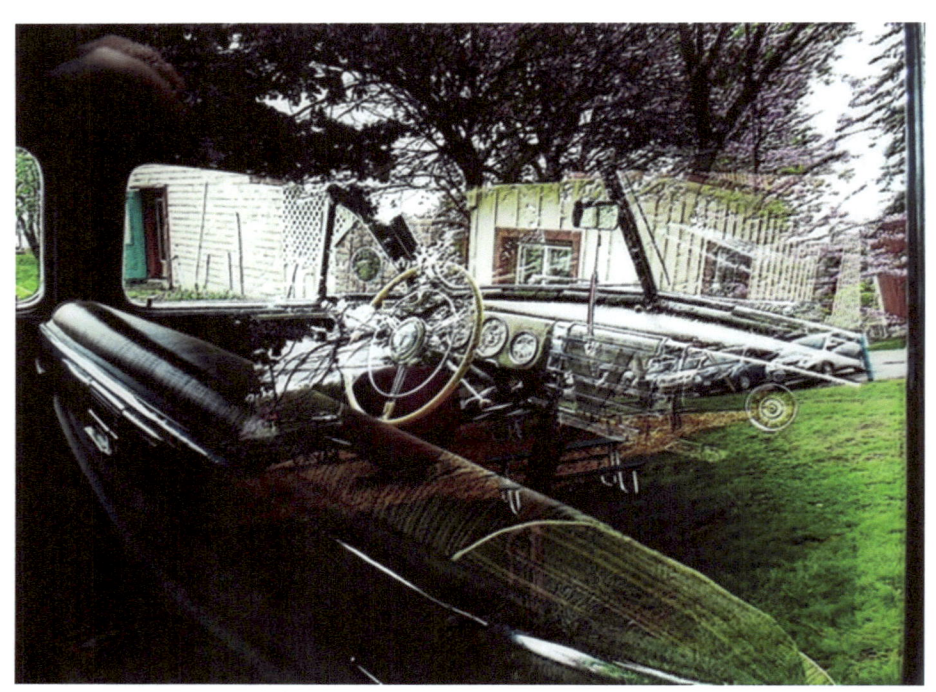

You are off again

drawn to another place

you will find

is just another place

you will, one day,

want to leave

an inner-dimensional

journey in a car with

a sketchy transmission

a flashing engine light

and spongy brakes

but you go anyway

a thermos of coffee

between your knees,

a badly folded map

on the passenger side floorboard

the rearview mirror

on the back seat

where you tossed it

the little spot of adhesive

that secured it to the windshield

serving as your North Star

as you navigate through this nebulous advance known as a life

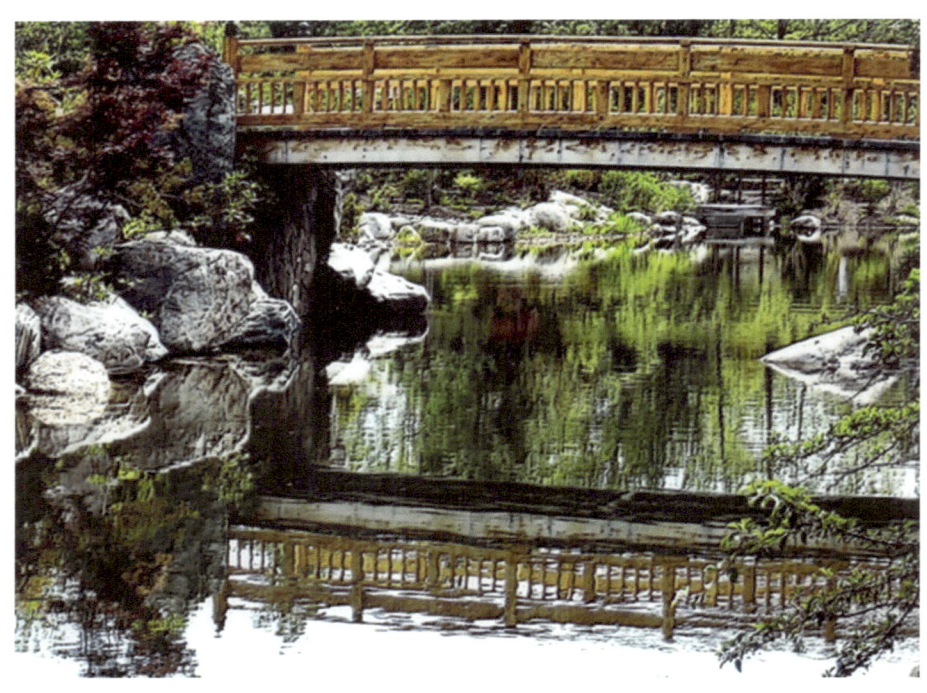

Looking over the railing

at an alternate you

walking over an alternate bridge

it is as if, for the duration

of the short traverse,

 you are living

 in an Escher print

all reversed yet connected

ripples exciting the reflection into

a kind of animation

of a chance encounter

with an old acquaintance

one you got along with

but only on perfect autumn

afternoons like this one

when there isn't heat enough

to trigger a temper

or cold enough to keep you

cooped up indoors where space

is usually only sufficient for one

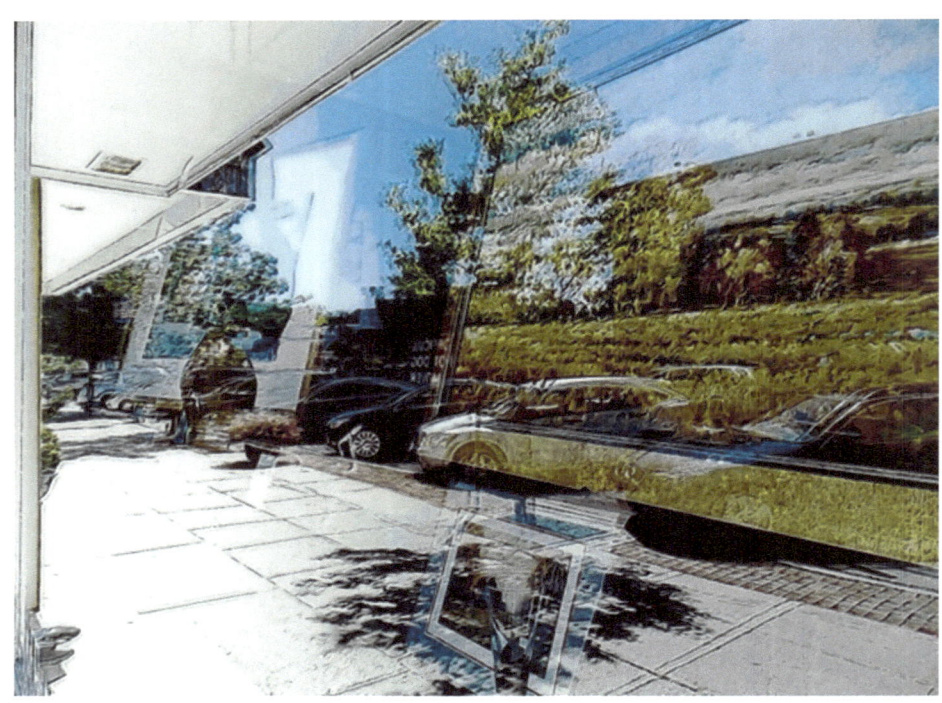

You lean closer to the

landscape behind

the glass

your eyes leading you

over every swirl

 into every wave

behind you

a hive of frantic blindlings

continues to pulse

as you move a finger

 along the glass

to explore the

shore of a lake

and to ascend

the mountain that

towers some

unimaginable

distance

away

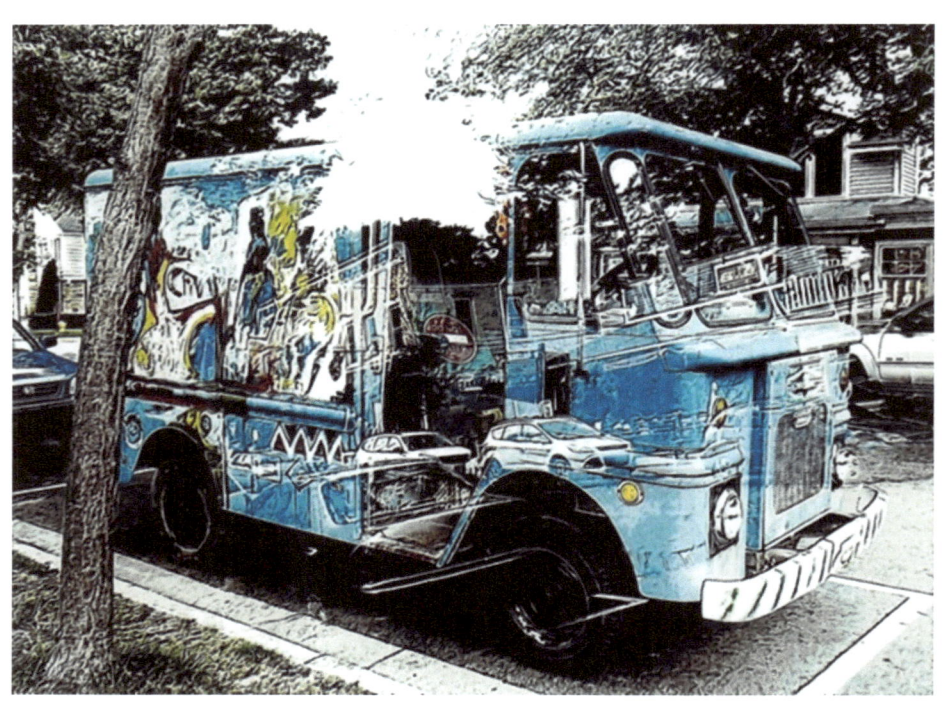

The calliope can still be heard

above the din of adulthood

if you take the time

to listen, if you

look through a window

so long fogged over

with a collection

of piddling concerns,

there will be,

pulling up to the curb,

a jalopy of dreams that

waits for you to join a

barefooted throng with your fistful of pennies

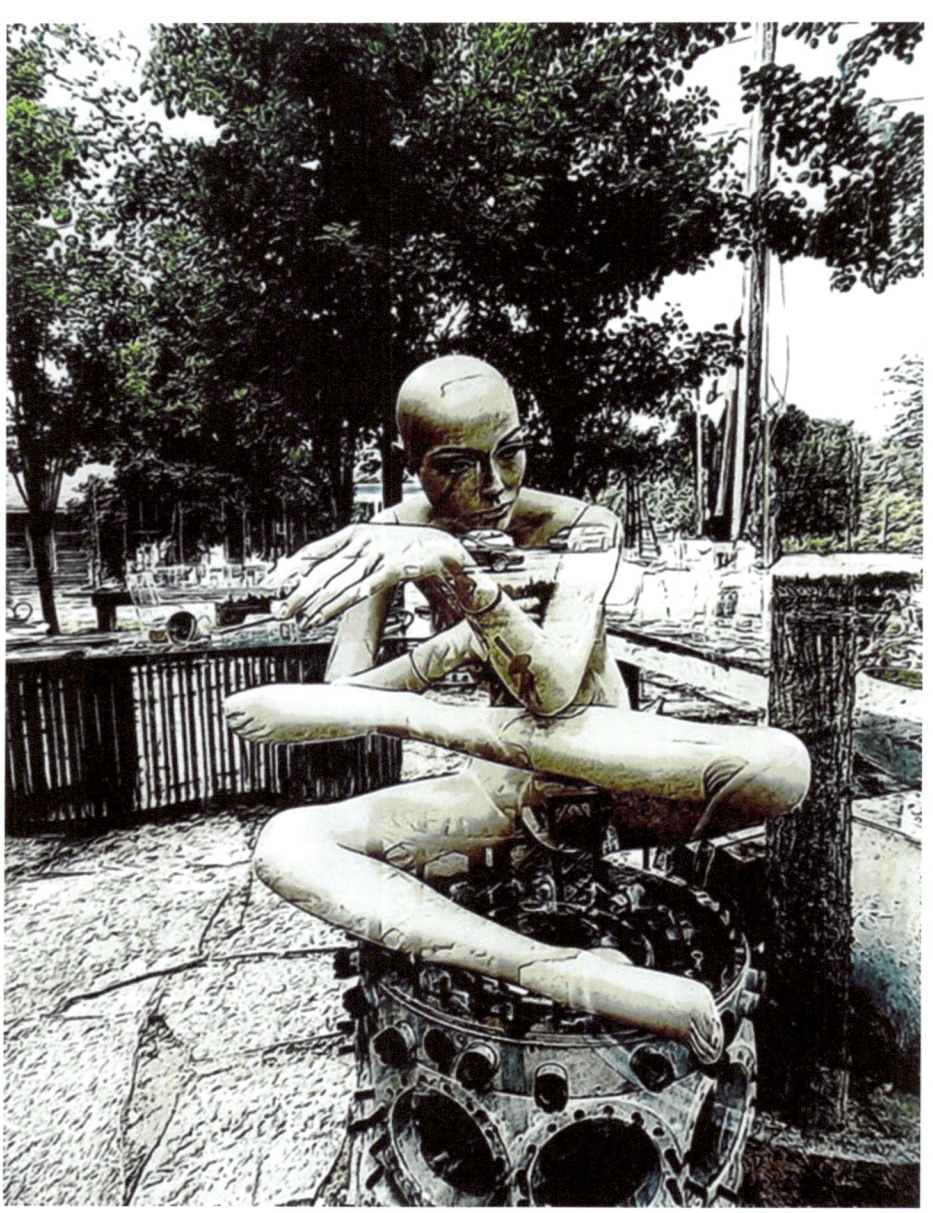

Emerging from meditation

one limb then another

unfolding slowly

to dry wings on the air you had used

to count your breaths

it is different here, the air

not as rich as it was in the world

you are leaving

thrown by a disruption of field

a fault in the bubble something

 - so you adjust using what

you've brought back

with you as a map

each point of growth

marked with a touch

the line connecting those points

becoming straighter with each awakening

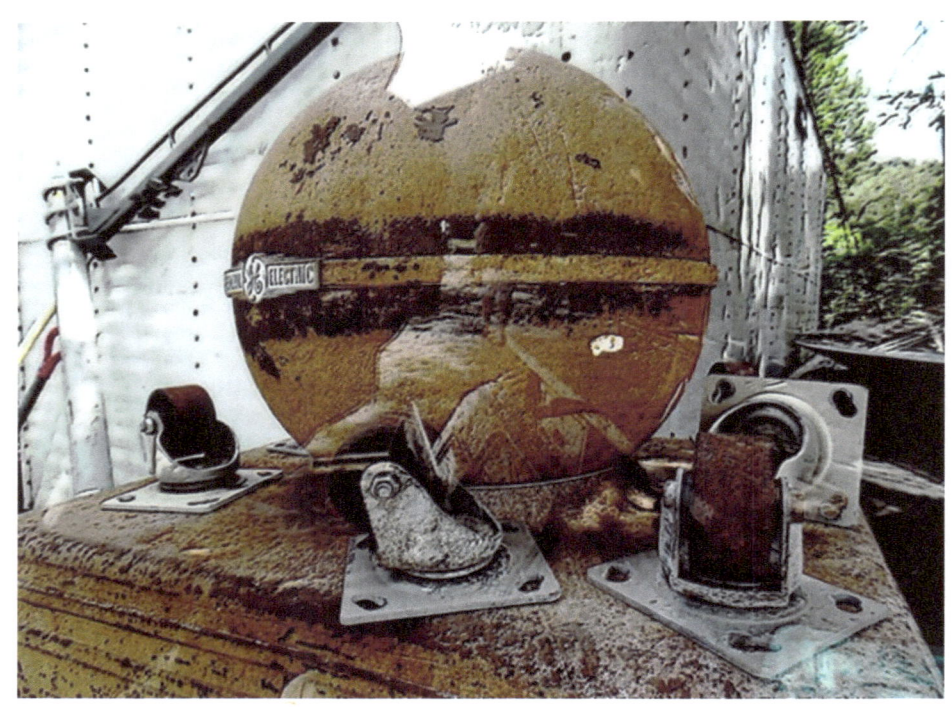

"and that

is Mars..."

she pointed it out to you

when you were seven or eight, a pale dot

in the east, rising above the lake

like a balloon free

from a child's grasp

and in doing so,

set your trajectory skyward

not knowing where you would land

or what, if anything, would

absorb the shock of impact

a precarious balance

she called it, this life

like the egg she would stand on end

 during springs equinox

briefly proving anything possible,

 even while enveloped by

 unseen forces

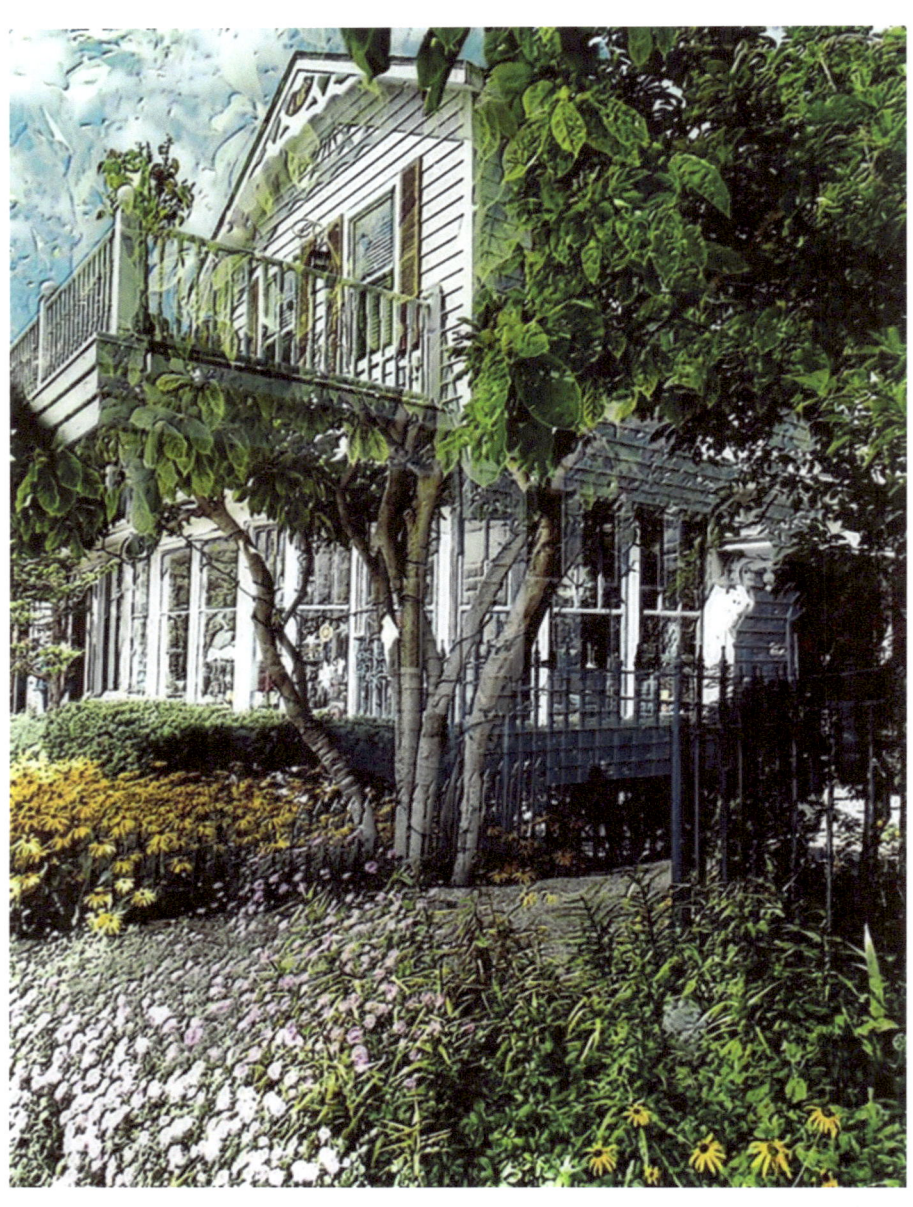

When asked where you go when

your eyes find the nearest window

and your sentences become disjointed

there is never an easy way to explain your cosmology

no way to clearly describe that place

where history was lovingly embellished

over glasses of lemonade, where

a Lilliputian guard patrolled the perimeter and

identification of birds was the afternoons entertainment

you resist being dragged away by the conversation

of those with no connection to this particular magic

and you pretend to focus

keeping always within sight

the magnolia that unfailingly blossoms for your return

every morning at 8:45

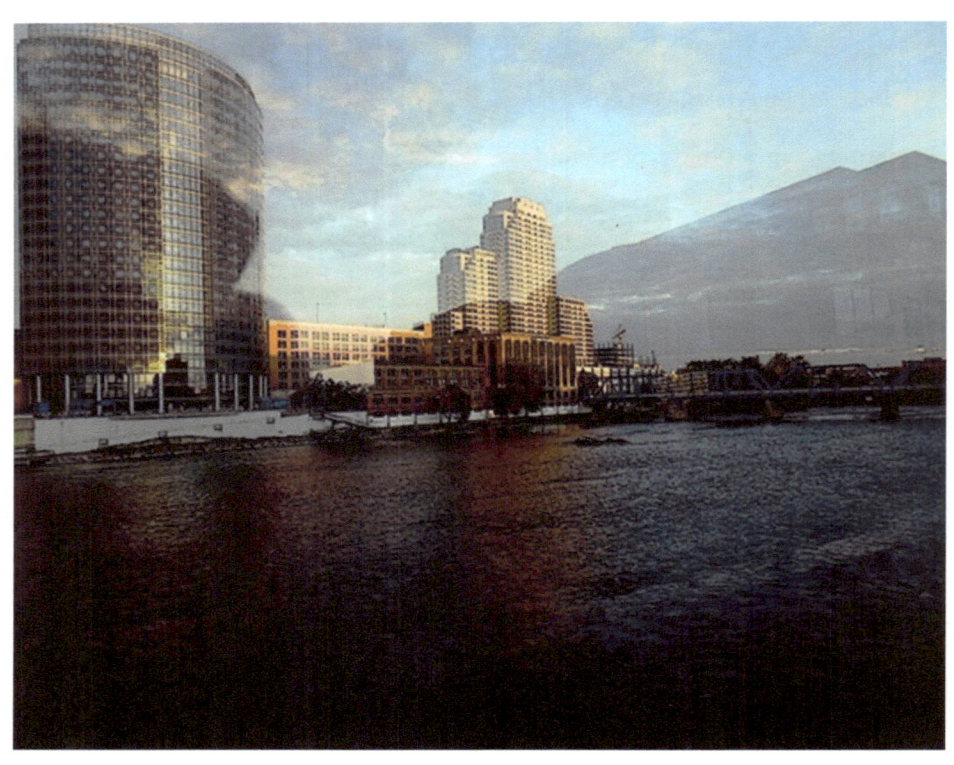

Our voices may have faltered

and for lack of singing

the song died

behind that spectral echo

a just born melody rises

soft as velour

its lightness embracing

the foothills of

a new generation

lifting our daughters

lifting our sons

toward the summit

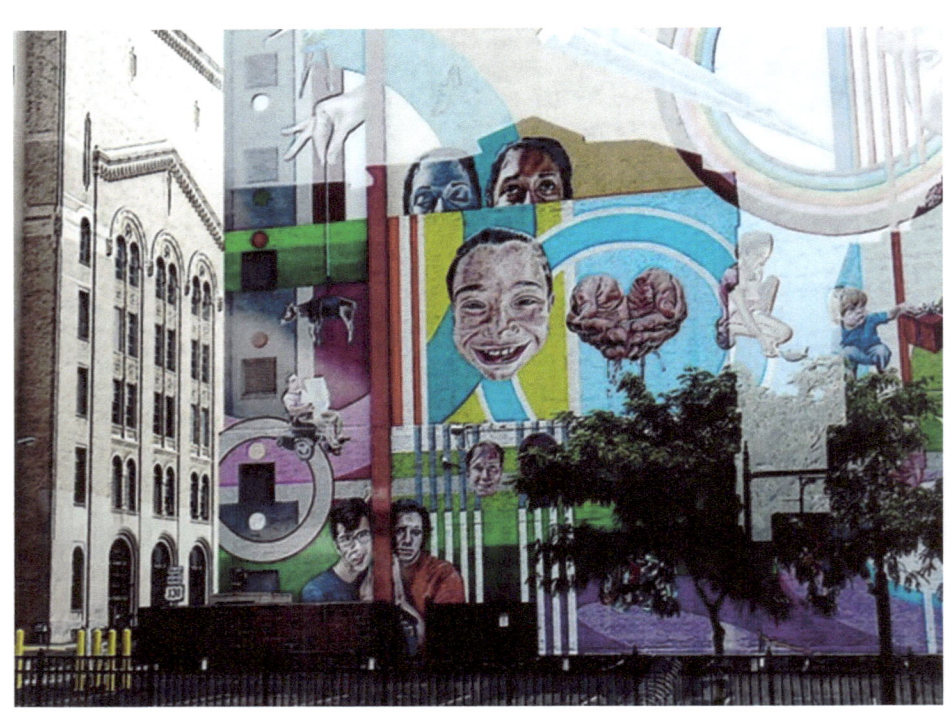

Sometimes

when they visit they conjure elegies

you meant so many times to recite

 sometimes

they raise a quiet laugh or draw forth a tear

and often the space

 between seems so long

you put yourself on trial

for not asking

them in sooner

and you always hope

that they stay to see you

through whatever tribulation

shoulders its way into

your day, but

they have already

done their part here

 carrying a bit of your load

so let them just check in

 from time to time

without a sense of duty,

 and raise a toast in their honor

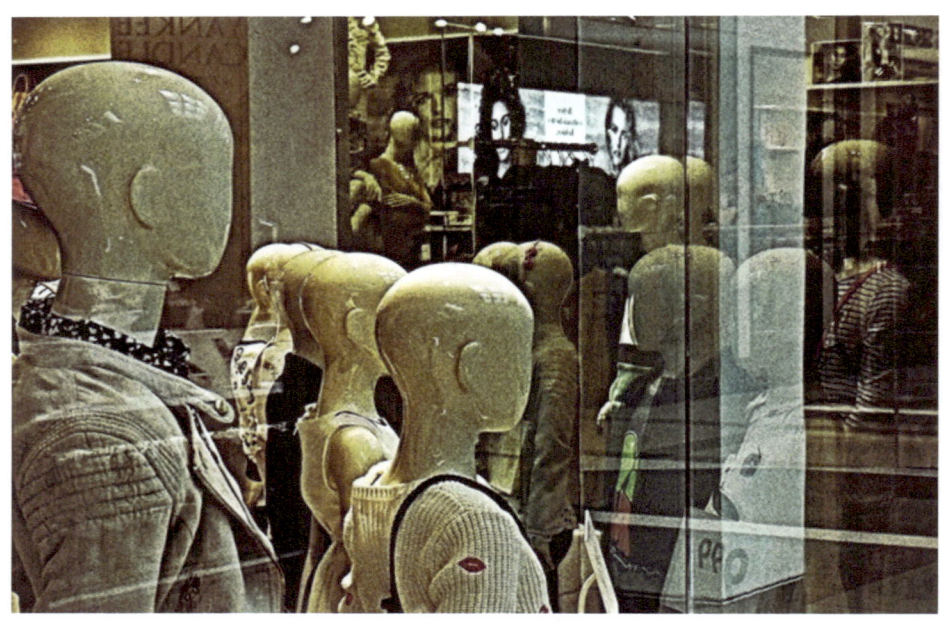

We gather

 as self-observed

 evolutionary beasts

wondering

if what we leave

will be enough to sustain

 all

 who come

 after

measuring progress

by the degree of disdain

blushing the faces

in our mirrors

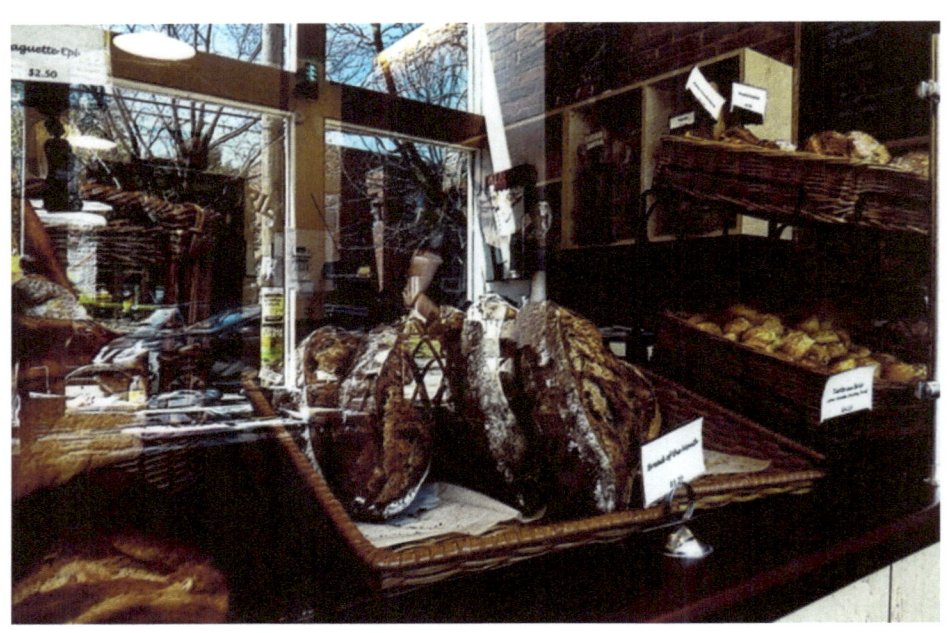

Even now

 long after

you have learned

the meaning of metaphor

a familiar symbol

seems to rise

from the mundane

and you briefly

take those myths

of your childhood

as golden truth

wanting to split the loaves

wanting to feed the world

www.ingramcontent.com/pod-product-compliance
Lightning Source LLC
Chambersburg PA
CBHW041150180526
45159CB00002BB/768